CHEKHOV IN HELL

Dan Rebellato

CHEKHOV IN HELL

OBERON BOOKS
LONDON

First published in 2010 by Oberon Books Ltd

521 Caledonian Road, London N7 9RH

Tel: 020 7607 3637 / Fax: 020 7607 3629

e-mail: info@oberonbooks.com

www.oberonbooks.com

A catalogue record for this book is available from the British Library.

ISBN: 978-1-84943-103-3

Cover design by Dragonfly Design

Printed in Great Britain by CPI Antony Rowe, Chippenham.

A Drum Theatre Plymouth Production

Chekhov In Hell by Dan Rebellato

CAST

ANTON CHEKHOV **Simon Gregor**

OLGA KNIPPER / NURSE / LANGUAGE STUDENT / WPC GREGORY /
CLAIRE WILLIS / JEMMA / LAP DANCER / CHERYL / VALERIE / KELLY
Emily Raymond

DOKTOR SCHWÖHRER / CARDIAC SPECIALIST / LANGUAGE
STUDENT / ALEKSANDR / STEVE / CLERGYMAN **Paul Rider**

GREGOR / DOCTOR / LANGUAGE STUDENT / JADE / MIKE /
SECURITY GUARD / MAX / JAMES WARD / POLICEMAN
Jonathan Broadbent

NICHOLAS / PHYSIOTHERAPIST / LANGUAGE STUDENT / PC
ASTON / NEIL / MARTIN / NICK / BOB / CRAIG **Geoffrey Lumb**

NICOLA / LANGUAGE STUDENT / SARAH / LAP DANCER / SALLY /
CATHY / MIMI / LYNN / MARCIA / SELINA / JESSICA / IRINA
Ruth Everett

CREATIVE TEAM

Director	Simon Stokes
Designer	Bob Bailey
Lighting Designer	Bruno Poet
Sound Designer	Adrienne Quartly
Casting	Lucy Jenkins and Sooki McShane
Russian Translator	Noah Birksted-Breen
Dialect Coach	William Connacher

PRODUCTION

Set, Props and Costume	TR2, Theatre Royal Production and Education Centre
Production Manager	Nick Soper
Costume Supervisor	Lorna Price
Stage Manager	Helen Gaynor
Deputy Stage Manager	Ian Hawkins
Assistant Stage Manager	Stevie Haighton
Drum Theatre Technician	Matt Hoyle
Wardrobe Mistress	Cheryl Hill
Wig Maker	Liz Recce

Chekhov in Hell was first performed on 4th November 2010 at the Drum
Theatre Plymouth

DRUM THEATRE

PLYMOUTH THEATRES

The Drum Theatre produces and presents new plays. As part of the Theatre Royal Plymouth we have built a national reputation for the quality of our programme and innovative work, winning the Peter Brook Empty Space Award in 2007. In addition to our own commissioned productions, we sometimes collaborate with other leading theatre companies including, most recently, Paines Plough, the Royal Court Theatre, ATC, Told by an Idiot, Frantic Assembly and the Belgian company, Ontroerend Goed.

In 2009 we co-produced a new experimental work, *Under the Influence*, with Ontroerend Goed for production in Plymouth and Ghent, before touring internationally and again collaborated in 2010 on *Teenage Riot*. Working with Told by an Idiot for the first time, we co-produced an adaptation of Michel Faber's *The Fahrenheit Twins* for national touring and a run at the Barbican Centre, London and we had major success with a new 'horror' comedy, *Grand Guignol* by Carl Grose. In 2010 we also co-produced Sarah Ruhl's *Eurydice* with ATC, DC Moore's *The Empire* with the Royal Court and *Love, Love, Love* by Mike Bartlett with Paines Plough. The Theatre Royal's Young Company and People's Company have residency in the Drum Theatre and perform there at least three times a year.

The Theatre Royal Plymouth is made up of the Theatre Royal and the Drum Theatre, as well as TR2, an innovative and award-wining Production and Education Centre housing the theatre-making process, rehearsal facilities and extensive education, access and development activities.

"At Plymouth they are maximizing the potential of those who could be the great theatre-makers of tomorrow...You only have to look around British theatre to see the Drum's fingerprints everywhere."
THE GUARDIAN

"What would British Theatre do without the Drum?" THE GUARDIAN

For the Drum Theatre Plymouth:

Chair **Sir Michael Lickiss**
Chief Executive **Adrian Vinken OBE**
Artistic Director **Simon Stokes**

Supported by
ARTS COUNCIL ENGLAND

Scenes

A note on production

A design but no set.

No props, unless Chekhov touches them. No costume unless Chekhov's wearing it.

There should be an *arbitrary* relationship between actor and character. Women can play men and vice versa, old playing young, etc. But not systematically. At points identity should be undecidable. Is Marcia black or white? I don't know.

None of the above applies to the first scene and not to Chekhov. (But what about Aleksandr, and Olga in the Northern Lights? I don't know.)

I'd like an audience to experience the scene titles. Spoken? Projected? Written? Printed? I don't know.

I think Scene 22 is a tear in the middle of things.

A note on the text

A slash in the middle of a speech marks the point where the next speech should start, creating an overlap.

Things in brackets that are not italicised, like (Star Wars), should be spoken.

'But he's got nothing on at all!' said a little child at last. 'Good gracious, listen to the voice of innocence,' said the father, and what the child had said was passed by whispers through the crowd until at last all the people cried, 'But he's got nothing on at all!' That made a deep impression upon the Emperor, who realised that they must be right, but thought, Nevertheless, I must carry on until the end. And the Chamberlains walked with yet greater dignity, carrying the Emperor's cloak, which did not exist.

Hans Christian Anderson

You ask me what life is. That's like asking what a carrot is. A carrot is a carrot, and there's nothing more to know.

Anton Chekhov

Prologue

2.00 AM. 2 July 1904. A room at the Hotel Sommer, Badenweiler, on the western edge of the Black Forest. ANTON CHEKHOV is in bed. He is feverish, sweating, coughing violently. By his right side is OLGA KNIPPER. DOCTOR SCHWÖHRER is administering camphor. Two Russian students, NICHOLAS and GREGOR, stand helplessly watching. The room is lit by low lamps and candles. The furniture is old and wooden. Olga has brought items from Moscow to Russify the room. French windows open onto a balcony. The set should be intensely realistic and detailed. The entire scene is in German and Russian.

ANTON: S moryak<u>o</u>m bed<u>a</u>.
 S moryak<u>o</u>m bed<u>a</u>.
 [The sailor is in trouble.
 The sailor is in trouble.]

OLGA: Doktor, bitte helfen Sie ihm!
 [Please, doctor, help him.]

ANTON: Vod<u>a</u> ledyan<u>a</u>ya
 Vokr<u>ug</u> nev<u>o</u> vod<u>a</u> ledyan<u>a</u>ya
 [Ice water.
 He sees ice water all around him.]

SCHWÖHRER: Der Kampfer sollte ihm beim Atmen helfen.
 [The camphor is supposed to help him breathe more easily.]

ANTON: Vidit nad soboj zhenu
 On<u>a</u> v si<u>ya</u>nii arkt<u>i</u>cheskom
 [He sees his wife rising above him
 A halo of Arctic light.]

OLGA: Er ist im Delirium.
 [He's delirious.]

SCHWÖHRER: Ja, ich weiß, er reagiert nicht auf den Kampfer.
 [I know. He's not responding to the camphor.]

GREGOR: Mozh<u>e</u>m my sh<u>to</u> to sd<u>e</u>lat'?
 [Is there anything we can do?]

OLGA: N<u>e</u>t, dorogie, osta<u>yo</u>tsta tol'ko molitsa.
 [No, my dears, just pray for him.]

ANTON: Olia, Olia.

OLGA: Ant**o**n, m**i**lyj.
[Anton, my darling…]

ANTON: Doktor…

OLGA: Er verlangt nach Ihnen.
Er will Ihnen was sagen.
[He wants you]

SCHWÖHRER: Ch**e**khov, Eto Doktor Schwöhrer.
[Chekhov. It's Dr. Schwöhrer.]

ANTON: Doktor . . .

SCHWÖHRER leans in.

(*Whispers.*) Ich sterbe.
[I'm dying.]

NICHOLAS: Sht**o** on skaz**a**l?
[What did he say?]

OLGA: Was hat er gesagt?
[What did he say?]

SCHWÖHRER: Nichts, nichts. Ich konnte es nicht verstehen.
Ich glaube ich werde ihm besser ein Sauerstoff-Kissen
besorgen.
[Nothing. Nothing. I couldn't make it out.
I think I should send for an oxygen pillow.]

ANTON: Net.
Net.
Ni k chem**u** eto. Pok**a** prines**u**t ya uzh**e** umr**u**.
[No.
No.
Why bother? I'll be dead before it arrives.]

OLGA: Ant**o**n, Ant**o**n, ne sm**e**j tak govor**i**t'.
[Anton, Anton. You mustn't say that.]

ANTON: Shamp**a**nskovo, Mn**e** by bok**a**l shamp**a**nskovo.
[Champagne. Let me have a glass of champagne.]

OLGA: Ant**o**n…

SCHWÖHRER: Er hat wohl recht.

Wir haben getan was wir konnten.

Geben Sie ihm seinen Champagner.

[I think he's right.

There's nothing we can do now.

Let him have his champagne.]

OLGA motions to the students.

OLGA: Shampanskovo.

[Champagne.]

The students pour a glass from an opened bottle and hand it to OLGA.
She holds it while ANTON drinks it.

ANTON: (*After a while.*) Davno ne pil ya shampanskovo.

[It's so long since I tasted champagne.]

ANTON lies down on his left side.

OLGA: Lyubov' moya. Milyj moj.

[My love. My darling.]

Silence. OLGA goes round the bed to see if Anton is breathing. OLGA
looks up at the doctor. SCHWÖHRER goes over to check. He listens
for a heart beat. He looks up at OLGA.

Anton! Anton!

She sobs over his body. The two students are crying. The doctor is
still staring. Bring in music, loud, Russian, stirring and sad. Fade
to black. In the blackout swiftly clear everything but CHEKHOV in
bed.

You're Having a Fucking Laugh

A hundred years later. Morning. CHEKHOV's in a hospital bed, wired to a heart monitor, fed with catheters, IV drips. None of this equipment is on stage. He drifts in and out of sleep during this scene. A SENIOR CONSULTANT and a NURSE on either side of him, echoing the previous scene. A nurse adjusts his bedding at some point. There is no bedding. They are wearing paper masks though we can't see them.

NICOLA: You're having a fucking laugh, intcha?

DOCTOR: I know this must be a shock.

NICOLA: I don't know who the fuck he is, I never seen him.

DOCTOR: According to what we have on file – not much, admittedly – he's a distant uncle of yours and he's been in a coma for a long time. Seventy years at least but we think longer.

NICOLA: Nah. This is fucking nutty.

DOCTOR: You're his only surviving relative, you and your daughter. According to as I say the file.

NICOLA: It's doing my head in.

DOCTOR: You are Nicola Chalker?

NICOLA: Yeah but –

DOCTOR: The file just says that when he wakes, we're to contact his surviving relatives. And he's woken up so we called you.

NICOLA: Fucking fruit and nut this is.

DOCTOR: Obviously, we will need to keep him in for a while longer. We need to run some tests. Check his reactions, brain functions, et cetera.

NICOLA: What are all the tubes for?

DOCTOR: He has some vestiges of a tubercular condition, complicated by emphysema. We've put him on a combination of isoniazid, rifampin and pyrazinamide

which should deal with the TB. We think it'll be easiest to put him straight onto a course of alpha-1 antitrypsin for the emphysema.

NICOLA: This mask is killing me.

DOCTOR: A necessary precaution I'm afraid.

NICOLA: Doesn't do much does he?

DOCTOR: He can speak.
(*Loudly.*) Antony.
This is Nicola Chalker.
She's your niece.
(He doesn't understand but we like to keep him involved.)
See? He's responding.

NICOLA: Should I hold his hand?

DOCTOR: If you want to.

NICOLA: Hello, Uncle.
Hasn't he got strong hands?
And nice eyes.

ANTON: Zdrastvuite. Tol'ko ya vas ne uznayu.
[Hello. I don't know who you are.]

NICOLA: What's wrong with him. Is he gone spastic?

DOCTOR: No, he's Russian. He's talking Russian.

NICOLA: Why?

ANTON: Zdrastvuite.
[Hello.]

NICOLA: (*Much miming.*) My. Name. Is. Nicola.

ANTON: Zdrastvuite Nicola. Menya zovut Anton.
[Hello Nicola. My name is Anton.]

NICOLA: Did he say my name?

DOCTOR: I think so. Hold on there's a list somewhere.

NICOLA: You've. Been. Asleep.

ANTON: Shto eto znachit?

[What does that mean?]

NICOLA: What is he saying?

DOCTOR: Hold on, hold on. Yup, 'Shto eto znachit' is 'what does that mean?'

NICOLA: 'Shto eto znachit?'

ANTON: Da. Shto eto znachit?
[Yes. What does that mean?]

DOCTOR: The human brain's a wonderful thing.

ANTON: Ospustite moyu ruku, pozhalujsta.
[Please let go of my hand.]

NICOLA: God, you can't shut him up once he gets going, can you?

DOCTOR: He gets very tired. Perhaps we could leave it there for now.

NICOLA: What's this about him being Russian?

DOCTOR: I'm to give you this. It explains everything, apparently.

NICOLA: I could do with one of those.

DOCTOR: Here we are.

NICOLA: Something that explains everything.

Pause.

DOCTOR: He's a mystery man. He was apparently in a private hospital in Germany but got transferred over here just before the War.

NICOLA: What war?

DOCTOR: Oh, you know. The War.

NICOLA: He's nice.
He's got nice / eyes.

NURSE: Eyes. Yes. (Sorry, sir.)

NICOLA: And his beard. I like his beard.
I think it's a shame guys don't wear beards any more.
Do you know what I mean?
Present company expected.
He's like your dad. Or the dad you wished your dad was.

DOCTOR: So – and obviously you don't have to make a snap
decision because this is absolutely, *absolutely*, your call
– but how would you feel about, when he's released, taking
him into your care?

NICOLA: My care?

DOCTOR: I really think he'd benefit from being looked after in
a warm family atmosphere.

NICOLA: My family don't have a warm family atmosphere.

DOCTOR: Well, of course, you don't have to make a snap
decision.

NICOLA: My care. You joking?

DOCTOR: Take a leaflet. Mull it over.

NICOLA: He should take care of me more like.
He looks – nice.
Like he knows stuff. Knows you better than you do.
Some people suit hospitals. Suit being in all the whiteness,
the white stuff.
Do you know what I mean?

DOCTOR: Well. You mustn't feel under an obligation.

NICOLA: I don't.

DOCTOR: Well you mustn't.

NICOLA: Shit. It's never half nine. Fuck.

DOCTOR: Okay, we'll keep him in isolation until we're sure
we're on top of the TB. Perhaps you could come in in a
fortnight or so?

NICOLA: Might do.
He's not infectious is he?

Only, I've got a little girl.

DOCTOR: You're quite alright. But it's why we insist you wear the mask.

We're Lost, We're Lost, We're Nowhere Now

Music, urgent. (I was thinking of The Secret Machines' 'Nowhere Again' when I wrote this scene. Maybe something more recent. No Coldplay or Kasabian though.)

We see CHEKHOV sitting up in bed being fed by a nurse.

CHEKHOV lying on his bed, being injected in the arse.

CHEKHOV watching television in astonishment.

CHEKHOV trying an iPod for the first time, roaring with amazed laughter.

CHEKHOV eating food himself, watched by a nurse.

CHEKHOV watching television in despair.

An emergency: doctors and surgeons surround the bed bringing CHEKHOV back from a cardiac arrest

We see CHEKHOV sitting on the edge of his bed looking around him in bewilderment.

CHEKHOV being reunited with his pince-nez.

The DOCTOR having his picture taken with CHEKHOV.

CHEKHOV watching television in tears.

CHEKHOV in physio. A physiotherapist is helping him to walk again. He's in a long nightshirt.

Speaking in a Purely Personal Capacity

Beside an empty bed.

NICOLA: What you talking about?

DOCTOR: He asked for some clothes last night and we thought well that's a good sign you know he wants to be independent which is something that we actually encourage at St Gabriel's, we encourage that, of course we do, we're not one of those dreadful hospitals you read about in the, in the, in the, my God, torturing old ladies and what have you; we're not some kind of *prison.*

NICOLA: You can say that afuckinggain.

DOCTOR: You've seen the wards. What, are we supposed to put you know armed guards on the doors? Because I mean, come *on.*

NURSE: There had always been a set of clothes, waiting for him.

DOCTOR: I don't think we can be held responsible for what is an exceptional situation.

NURSE: A light-coloured flannel suit. A pair of leather shoes. A shirt and tie.

DOCTOR: It's protocol. As long as it doesn't conflict with the patient's treatment, respond willingly to the patient's wishes.

NURSE: A hundred years ago I mean it's incredible to think of it now but a hundred years ago they would give a patient a dying patient champagne if he asked for it which to me is taking things way way you know even on BUPA but it's the same principle.

DOCTOR: So we thought, why not?

NURSE: We thought (exactly) why not? A suit of *clothes,* come *on.* So we gave them to him. Simple as that.

DOCTOR: And frankly, notwithstanding this unfortunate
 incident, I would do it again. Yes I would, because giving
 a a a a a pair of shoes, my God we're talking about a pair
 of *shoes,* to an old man, you know? It's hardly a crime – in
 fact quite the reverse, in my professional opinion. Because
 this hospital is not a a a a a a a a a a well I mean I've said it
 already, a a a prison. I'm repeating myself now but it's, you
 know? Do we have no principles any more? is the point.
 Is there not such a thing as compassion, even in a hospital.
 You know?

NICOLA: Do you know how old he is?

 Beat.

 A hundred and fifty.
 An hundred-and-fifty-year-old bloke walks out the door
 and no one fucking stops him?

DOCTOR: (*Voice trembling with compassion.*) A pair of *shoes* –

NICOLA: He could be miles away.

DOCTOR: Needless to say I have already launched a full
 investigation.

NICOLA: Oh woop-de-fucking-do.

DOCTOR: Legally, we've been advised not to apologise but off
 the record I would like to say that I regret – in a personal
 capacity – what has happened and not as an employee but
 as a – let's say – 'human being' I I I I sympathise with what
 you must be feeling.

NURSE: It is a matter of deep regret: that I think we *can* say
 without prejudice to the interest of the Primary Care Trust.

NICOLA: You know, when I left last time, I was taking my girl
 to school and I thought, nah, fuck it Nicky, you don't need
 this.

DOCTOR: I understand.

NICOLA: But it was weird
 I keep thinking about him.

He's nice.

Not in that way I just mean he's got a nice face.

NURSE: Yes, he has.

NICOLA: I'd made up my mind pretty much I'd take him home when you phoned to say there's been a situation. I thought: I don't know who he is but he's old, he's got to know stuff, even if he's been in his bed an hundred years, he's got to be like wise and stuff yeah? He can help me, help me to forget the noise and stuff, give me something else, you know? Make things bright. And white. Pull me through. Make stuff better. Like Jesus but not.

And by the way I wouldn't call this a situation, I'd call this a fuck up.

NURSE: We know you're upset –

DOCTOR: No. It is. It is a terrible fuck up.

NURSE: No –

DOCTOR: No. Fuck the law. Fuck it.

We did wrong.

NURSE: My colleague is speaking in a / purely personal capacity.

DOCTOR: We fucked up and I'm sorry. On behalf of the Primary Care Trust I accept full responsibility.

(God that feels good.)

NURSE: Doctor…

DOCTOR: I'm to blame! It's my fault!

NURSE: Doctor, please.

DOCTOR: No. I let the oldest man in the world walk out of this hospital. I accept the consequences.

NURSE: The doctor does not speak with the authority of the Trust. Please, Doctor. Pull yourself together.

NICOLA: S'anyone got any clue where he's gone?

DOCTOR: You read the file. Anything in there?

NICOLA: Nothing really.

DOCTOR: Do we know what he did, does?

NICOLA: It's very confusing. Not sure if he was a doctor or a writer.

NURSE: If he was a, writer, he'll probably have gone to the pub. Ha ha. I can say that because my brother-in-law's a writer.

DOCTOR: A writer? Oh what a shame. I was rather hoping he'd be the last of the Romanoffs or something.

NURSE: Maybe he wants to write about something. Though if he wanted to do that he should have stayed in the hospital. You got all the material you need in the nurse's lounge. We got some stories you could put straight in a book.

NICOLA: Did he say anything?

DOCTOR: Nothing much. Hello. Water. Where am I? That sort of thing.

NURSE: He talked in his sleep though.

DOCTOR: Oh did he?

NURSE: Yes. Apparently he was talking to his wife. His wife was floating in the sky. She was in the Northern Lights and he was trying to reach her.

DOCTOR: Speak good Russian do you, nurse?

NURSE: The cleaner does. She translated.

DOCTOR: Well it's all gibberish anyway. Quite usual in advanced pulmonary tubercular conditions.

NICOLA: Sounds sad though.

NURSE: Yes.

DOCTOR: He can't even speak English, remember. I'm sure the police will pick him up.

I Was In A Bad Place Back There

Aggressive music. An EFL class. Rows of foreign students, CHEKHOV included (now in his light-coloured flannel suit, shirt, tie, hat and pince-nez.) repeating as a group in their respective foreign accents phrases they hear on headphones.

STUDENTS: 'Leave it, mate, he's not worth it.'

> *Pause.*
> 'I was in a bad place back there.'

> *Pause.*
> 'Oh. My. Gosh. Oh. My. *Days.*'

> *Pause.*
> 'Fo shizzle my nizzle.'

> *Pause.*
> 'You are chatting shit. End of.'

> *Pause.*
> 'Unexpected item in the bagging area'

> *The music rises to drown them.*

Getting Used To The Sky

A park. A young girl is throwing a ball high into the air and catching it.

ANTON: Hello young man.

JADE: You what?

ANTON: What?

JADE: I'm a girl.

ANTON: Sorry.

JADE: 'Young man'. What's that about?

ANTON: I sorry. Mistake.

JADE: Okay. You're forgiven. Now piss off.

ANTON: How old are you please?

JADE: I'm twelve.

ANTON: Really?

JADE: I'm old for my age.

ANTON: Okay.

JADE: What are you doing here?

ANTON: I want understand.

JADE: Understand what?

ANTON: What happen here.

JADE: Nothing happened here, granddad.

 Pause.

ANTON: Why you are throwing the ball?

JADE: So I can catch it.

ANTON: Catch ball.

JADE: Yeah, catch ball.

ANTON: Up.

JADE: Yeah up, in the sky.

ANTON: Sky.

JADE: Fucking sky granddad.
 Got to get used to it.
 Fucking huge sky.

Two police officers appear.

WPC: Are you alright, love?

JADE: Yeah.

WPC: He's not bothering you is he?

JADE: Just talking.

PC: You usually talk to girls in the park?

ANTON: Sometime. Who are please?

PC: I'm PC Aston and my colleague is WPC Gregory.

ANTON: You work in park?

WPC: What, 'sthis is a park keeper's uniform is it?

ANTON: I not know.

PC: You live round here do you?

ANTON: No, come from other place.

PC: Do you have any means of identification on you, sir?

ANTON: Identif –

PC: Travel documents?

ANTON: Travel –

WPC: Are you in fact a British resident sir?

JADE: Is he a perv?

ANTON: I am Russian.

WPC: How did you get here?

ANTON: I not understand.

PC: I take it you came here legally? You do have a right to remain yes?

WPC: / (*Into phone.*) Can we get a car to Mackenzie Park? North gate? We've got a suspected illegal. Yeah, Russian he says. Quick as you like.

JADE: I knew he was a perv.

ANTON: I have done something wrong?

PC: Something wrong? Who said anything about doing something wrong?

ANTON: Is private park?

PC: We just want to ask you a few questions. You do not have to say anything but it may harm your defence if you do not / mention something which you later rely on in court. Anything you do say may be given in evidence.

ANTON: My defence?

WPC: (*To phone.*) Yeah, we're bringing him in now.

ANTON: Please – do not touch me.

WPC: Okay, sir, take it easy, we're not going to hurt you.

PC: Just calm down, sir, and we'll talk about this back in the station.

ANTON: The station?

JADE: Is he a terrorist?

PC: We're going in a vroom-vroom.

ALEKSANDR has appeared.

ALEKSANDR: Hey hey hey. Come on.

PC: And who are you, sir?

ALEKSANDR: You okay?

ANTON: What they do?

ALEKSANDR: You are arresting this man?

PC: This is none of your business, sir, please keep away.

ALEKSANDR: You are Russian, yes? Vi rooskiy?

ANTON: Da. Da. Rooskiy.
 [Yes. Yes. Russian.]

WPC: Keep out of this sir, or we will place you under arrest.

ALEKSANDR: You are arresting him? Oni aryestovali Vas?
 [Have they arrested you?]

ANTON: Ya nye znayoo.
 [I don't know]

WPC: I'm warning you sir –

ALEKSANDR: Hey, I'm talking. I can't talk now?

PC: You are obstructing the / police in the course of their –

ALEKSANDR: Obstructing you? I'm talking to this man.

PC: This man is helping us with our enquiries –

ALEKSANDR: And I'm helping him. / Have you put this man under arrest?

ANTON: Thank you.

PC: You want to get nicked?

ALEKSANDR: Oh you arrest me now?

PC: Listen sir, we are trying to verify this gentleman's right to remain / and if you persist in obstructing our enquiries we will have no alternative but to – please calm down and listen to me, sir.

WPC: (*On phone.*) Hi yeah, this is WPC Gregory again, yeah, we might need to bring two of them in / and we're requesting back up if possible. Yeah, maybe two cars because he's sorry I can't hear you there's a lot of shouting this end. No I said two cars because – yes yes. No I think it's under control it's just getting a bit loud.

ALEKSANDR: What is she doing? Request back up? What is this? This is some fucked-up shit man. / What is she doing?

PC: Do not raise your voice at / me, sir.

ALEKSANDR: Always you do this. Russian guy, must be dodgy, bring them in; you don't hassle me, you don't / hassle him, okay?

PC: Are you threatening a / police officer?

ALEKSANDR: Threat? What / threat?

PC: Sounded like a threat / to me, sir.

ALEKSANDR: Hey, you don't talk to me this way. / I done nothing –

PC: Right, this is your final warning. Fuck off or you're under arrest.

ALEKSANDR: (*Whips out a massive handgun from a shoulder holster in one fluid movement.*) GET DOWN ON THE MUTHAFUCKING GROUND MUTHAFUCKAS!

OFFICERS drop. So does JADE.

ANTON: /What you do? What you do?

PC: / Take it easy, sir. Take it easy. Take it easy..

WPC: Don't shoot. Please. Please, don't shoot.

ANTON: No. No. No.

ALEKSANDR: DON'T MOVE DON'T LOOK UP DON'T FUCK WITH ME YOU FUCK WITH ME YOU'RE DEAD YOU UNDERSTAND ME?

PCS: (*ad lib.*) Yes, yes.

ALEKSANDR: THROW ME YOUR PHONES AND STAY ON THE MUTHAFUCKING GROUND TILL WE ARE OUT OF SIGHT AND MORE MUTHAFUCKAS.

Police officers obey. ANTON and ALEKSANDR make their escape.

ANTON: Oh my days. Who are you? What you do?

Missing Persons

Telephone call. Not necessarily with telephones.

CLAIRE: Nicola Chalker?

NICOLA: Yeah.

CLAIRE: I'm Claire Willis, I'm a police community support officer and I've been assigned to your case. I understand you've reported a missing person.

NICOLA: That's right.

CLAIRE: That must be very upsetting for you, Ms Chalker or can I call you Nicola or indeed Nicky, because there's a note on your file that you like to be called Nicky.

NICOLA: Yes, Nicky's fine.

CLAIRE: Only it's quite informal so I do like to check before proceeding.

NICOLA: No, it's fine. Nicky, Nicola, whatever. (Jess, will you hurry up and get ready for school, I'm not telling you again.)

CLAIRE: Thanks Nicky, because what I'm here to do is ensure that you have all the support you need at this difficult time because it *is* a difficult time and often people don't know where to turn do they? So what I'm saying, Nicky, is that I am in effect your one-stop shop to coin a phrase for anything that you may or may not need whilst we endeavour to locate your missing person.

NICOLA: Right, okay. So, you'll keep me informed when –

CLAIRE: I am available day or night to answer any enquiries that you may or may not have because I will be giving you at the conclusion of this phone call my personal mobile number and therefore should I not be temporarily available I will be able to get back to you just as soon as poss. Okay?

NICOLA: Right, okay, so – ?

CLAIRE: And not just for information, Nicky, in fact. Because actually if you just need a chat or a big old cry or something in that ball park I'm here for that too because how often do we all just want a shoulder to cry on and sometimes, Nicky, a shoulder isn't to hand?

NICOLA: Is this new?

CLAIRE: It's quite new.

NICOLA: Cos I got burgled last year and I didn't get any of this.

CLAIRE: It's a new initiative because crime isn't just about stuff getting nicked, it's also about what goes on in here. (I'm pointing to my heart, Nicky.)

NICOLA: Okay.

CLAIRE: And do you have any other questions at this moment in time?

NICOLA: Well, have you found him?

CLAIRE: Have we found him. Well nothing's coming up on my screen, Nicky, and if we had located your (*reads*) uncle it would be coming up on my screen so I have to say no I don't believe we have found him. I'm sorry Nicky. I know that will be very disappointing for you.

NICOLA: No well, I didn't really think you'd've –

CLAIRE: No, Nicky, no. You mustn't despair / because that way depression lies and you don't want that and anyway

NICOLA: I wasn't despairing –

CLAIRE: I have a very good feeling about this case, call it a hunch, call it whatever, but I am 100% we're going to find him. Something in my water. Are you superstitious, Nicky?

NICOLA: No, not really.

CLAIRE: Well you might like to start because I find superstition a tremendous comfort.

NICOLA: Thank you.

CLAIRE: What I'm going to do now, Nicky, is I'm going to give you my personal mobile number. Do you have a pen and paper handy?

A Kind of Travel Agent

Coffee shop.

ANTON: Spasibo za pomosh.
[Thank you for your help]

ALEKSANDR: (*Urgently.*) No. Talk English

ANTON: No pochyemoo?
[But why?]

ALEKSANDR: (*Finger on lips.*) Police.

ANTON: Ya nye ponimayoo –
[I don't understand –]

ALEKSANDR: You are English gentleman. I am English
gentleman. We have business meeting. We make jokes, we
talk about football. Take this. (*Baseball cap.*)

ANTON: What is?

ALEKSANDR: Put it on.

ANTON: What this mean?

ALEKSANDR: It means: just do it. That is better; now you are
ordinary English guy.

ANTON: English wear this?

ALEKSANDR: Sure they do.

ANTON: Thank you help, I think.

ALEKSANDR: It's nothing. A Russian man is in trouble,
Aleksandr Polzin help, you know? I do you a favour, you
do me a favour, that's how the world works.

ANTON: I not can help you I think.

ALEKSANDR: Hey, my friend, not today, not tomorrow, some
day, whenever.

ANTON: Thank you, Aleksandr.

ALEKSANDR: Call me Sasha.

ANTON: Okay and I am Anton. Anton Chekhov.

ALEKSANDR bursts out laughing.

This is funny in English?

ALEKSANDR: You poor bastard.

ANTON: Sorry?

ALEKSANDR: 'Anton Chekhov'!

ANTON: Yes.

ALEKSANDR: You haven't heard of Anton Chekhov?

ANTON: I not think so.

ALEKSANDR: You poor bastard.

ANTON: I am in the hospital.

ALEKSANDR: How long? Hundred years? (*laughs.*)

ANTON: I think so.

ALEKSANDR: (*Laughs.*) You're funny. This is good. English like funny. All the time. Funny funny funny. It makes me sad.

ANTON: I sorry.

ALEKSANDR: What do you do, Anton Chekhov?

ANTON: I am a – a writer.

ALEKSANDR: Of course!

ANTON: (*Confused*) What?

ALEKSANDR: I don't have time for reading, Anton Chekhov. Business take up all my time.

ANTON: What is business?

ALEKSANDR: I am a kind of travel agent.

ANTON: I understand.

ALEKSANDR: Someone wants to travel, wants to come to England. I help them.

ANTON: Okay.

ALEKSANDR: Find them a place to live, get them a job, give little money to buy pretty things.

ANTON: Where from these people come?

ALEKSANDR: All over. But at the moment lots of girls coming from Russia, Ukraine. Albania also.

ANTON: Girls.

ALEKSANDR: Yeah. It's pretty much just girls. You like girls, Anton Chekhov?

ANTON: I married.

ALEKSANDR: Hey, we're just talking. Where is your wife?

ANTON: I not know.

ALEKSANDR: Ah that's too bad. Where you last see her?

ANTON: In the sky. I see my Olga in the sky.

ALEKSANDR: Huh. Okay. I am looking for a girl too. Irina.

ANTON: She your wife?

ALEKSANDR: No. Just a girl. I brought her here, with my agency. She ran away to another, another agency. A bad man. Nick. Bad, bad man.

ANTON: Why she run away?

ALEKSANDR: Cos she is ungrateful girl. There are girls like this, my friend. Keep away from these girls.

ANTON: Is problem?

ALEKSANDR: In my business, Anton Chekhov, girl go to other agency and not ask me, it look bad.

ANTON: What you do?

ALEKSANDR: I will find Nick. And we will have a conversation. And then I will find Irina.

ANTON: You can find Nick?

ALEKSANDR: Nick is a bad man. He hide behind many doors. But I find a way. Anyway now you tell me, Anton Chekhov: what the police want with you?

ANTON: I not know.

ALEKSANDR: You can talk to me.

ANTON: They want passport.

ALEKSANDR: You have passport?

ANTON: No.

ALEKSANDR: You need a passport, my friend.

ANTON: I take these from hospital.

ALEKSANDR looks through the random assortment of documents. He is taken with one of them.

ALEKSANDR: No these are all – oh okay, this one is good. You can get passport with this.

ANTON: I can?

ALEKSANDR: Sure. Cost a little money maybe.

ANTON: Ah. No money.

ALEKSANDR: I get you a passport. I like you. This is how the world works.

ANTON: You very kind, help me.

ALEKSANDR: What is the world if a man does not help another man?

ANTON: I very thank you, Sasha.

ALEKSANDR: I take this. And I get you a passport. And the police not bother you no more.

ANTON: Thank you.

ALEKSANDR: You will be English gentleman.

ANTON: How will you find me?

ALEKSANDR: I found you, didn't I?

ALEKSANDR folds the document and puts it in his pocket.

Because The Way They Treat Those People

Telephone call. Not necessarily with telephones.

CLAIRE: Well, Nicky, we've got some good news and some not-so-good news.

NICOLA: Oh God, what?

CLAIRE: The good news is we located your Uncle.

NICOLA: Oh wow, seriously? That's amazing.

CLAIRE: Well yes it is, bit of luck actually. Two officers on patrol spotted him in the park.

NICOLA: How is he?

CLAIRE: Appears to be in in in rude health and very vigorous so that's good news.

NICOLA: Where is he? Can I see him?

CLAIRE: Well, this is where it gets a tad complicated.

NICOLA: Excuse me a minute. (Turn it down Jess, it's much too loud.) (*Changes ears*).

CLAIRE: Okay well here's the thing. Our officers had reason to believe that he might be in the country illegally.

NICOLA: Illegally?

CLAIRE: I know, I know.

NICOLA: What does that mean?

CLAIRE: I know, because the way they treat those people.

She shakes her head sympathetically.

NICOLA: Hello?

CLAIRE: I'm shaking my head sympathetically, Nicky.

NICOLA: So what happened?

CLAIRE: Well, yes, they *were* in the process of taking him in when he escaped.

NICOLA: Escaped?

CLAIRE: Yes, it seems that as he was being taken into custody he was rescued by a known Russian gangster with links to international people trafficking who overpowered the police at gunpoint and together they made their escape.

NICOLA: You're kidding me.

CLAIRE: These things happen, I'm afraid.

NICOLA: I don't believe it.

CLAIRE: That's what is says on my screen. I'm just heading out for a home visit but if you need a hug I can pop round after nine. Okay?

Plasma Screens are Cheaper Than Windows

ANTON and STEVE are wearing hard hats.

STEVE: Mind your head there.

No as I say this used to be a playground till the junkies took over.

ANTON: Please?

STEVE: Junkies, addicted to drugs and shit.

ANTON: Ah.

STEVE: Yeah so the council closed it and sold off the land. Hence all this.

Watch your feet there.

So all the flats are designed on the same lines, though they flip on the other side of the green. (I say green it *will* be green.)

Each unit has a kitchen/living room. The kitchen will go in there. Hob, microwave, dishwasher, we did a deal with a Swedish firm.

And the family can sit round the table here to see what mum's cooking up.

ANTON: Family?

STEVE: Yeah, this way they can smell it before it gets to the table. It's a sort of Bisto thing.

ANTON: Please?

STEVE: Don't they have Bisto in Ruskyland? Poor bastards. Sitting round a table on a Sunday, nothing like it. I spect it's all cabbage. 'With this potato, Babushka, you're really spoiling us.' Only joking, actually, because you got that caviar and shit so fair play to ya.

No what is special about this development – mind there are some cables there, yeah, no it's alright just mind – yeah is that the rooms are designed on computer to be optimal in size.

Cos architects are, well (*a*) they're expensive, because what

the fuck do they do actually? (Draw a picture of a house and say get on with it) And (*b*) because they get stuck on stuff and they have ideas and concepts. You know, we need flows of light, and a fucking atrium and everyone needs windows, you know, fucking…
So yeah so we invested in a bit of software.
It's the stuff that you put a computer. (Doesn't matter)
Yeah. This guy, software engineer, works in Reading, brilliant bloke actually, done lots of stuff for XBox, designed some of the textures for the new *Halo* as it goes, but anyway.
You just punch in the parameters you want. Total square metres, number of inhabitants, any unmoveables (structural shit, mainly), and it gives you the optimal ground plan for your parameters. And what it does is it encourages you to think outside the box.
We were putting this stuff in and it was coming out okay but not great, 11K a unit something like that and this guy, he's a total legend as he goes, he's like, go into 'options' and see if there's anything you can uncheck.
And we go in and there's this list: power points, cupboard space, windows. And they're all checked, so you uncheck windows and this is what you get. 5½K per unit.
Which means it's cheaper to hang plasma screens than windows. And frankly there's fuck all to see out there anyway. Load of junkies going where's my fucking playground, know what I mean?
There's two smaller bedrooms down the corridor, don't go in cos there's nothing there. Really, you'll go down six flights.

ANTON: Thank you.

STEVE: Nah cos it's easy to be money about it all and it's all 25K for this, 100K for that, but at the end of the day it's about creating somewhere in which people are going to be happy.
And sometimes I look at this stuff, because it's homes, you know what I mean, fucking homes, people are going to live here for years and years and years, you're making space

for people to live, and sleep, and eat and raise a family
and all that. And then I look at what we're doing here and
sometimes I cry.
You know, you're very easy to talk to.

ANTON smiles vaguely.

Jemma is a Chair

A circle of chairs.

NEIL: That's a difficult one.

SARAH: Take your time, Neil.

NEIL: I think you would be
I think you would be

SARAH: Whatever comes to mind.

NEIL: I think you would be
A rhinoceros.

The group claps.

SARAH: Okay. Great.

MIKE: I'm good with that. Thanks Neil.

SARAH: Well maybe you'd like to go next. Perhaps ... Jemma?
Is that okay Jemma? Mike, if Jemma were an item of
furniture, what item of furniture would she be?

MIKE: Okay, furniture. That's hard.

SARAH: It's just a way of –

MIKE: Yes yeah.

JEMMA: Make it nice!

SARAH: Ha ha, no but Jemma, do let him – you know.

MIKE: You would beeeee aaaaaaaa
A comfortable old armchair.

The group claps.

JEMMA: Oh cheers.

MIKE: What?

JEMMA: A nice saggy old armchair. Very flattering.

MIKE: I didn't say saggy.

JEMMA: Can we please remember I was actually abused? That sort of thing's bloody hurtful.

SARAH: Jemma, remember: we're all hurting in this room.

JEMMA: He didn't call you saggy.

NEIL: If you don't want people to call you saggy you shouldn't wear that top.

JEMMA: Surely *that's* not allowed.

SARAH: No, you're right. Neil, do you want to apologise to Jemma?

NEIL: Sorry Jemma.

SARAH: Thank you, Neil. Jemma, would you like to go next?

JEMMA: Who'm I doing?

SARAH: Well what about our new member? Perhaps you'd like to tell us your name?

ANTON: My name is Anton.

ALL: Hello Anton.

SARAH: And what brings you to Survivors?

ANTON: I have just woken up.

The group claps.

SARAH: I think a lot of people here feel like that.

Agreement.

So Jemma, if Anton were a, say, ornament what ornament would he be?

JEMMA: Okay, right.

Pause.

It's difficult cos I don't know him, you, sorry.

MIKE: I've got one.

JEMMA: It's my go.

SARAH: Yes, it really is Jemma's go.

JEMMA: I think you would be

MIKE: A Russian Doll.

JEMMA: It's my go.

NEIL: That *is* a good one though.

JEMMA: No it is not a good one.

SARAH: Well, Jemma, we don't judge each other like that do we?

JEMMA: It's my *go*.

SARAH: That's right, it is your go but you still shouldn't be rude to Mike.

JEMMA: What's so special about Mike? He's just a shopaholic. I was bloody abused.

SARAH: No, Jemma, if someone needs Survivors for whatever reason, we accept them into the circle.

JEMMA: Yes, like that guy who was depressed because they cancelled *Ugly Betty*.

NEIL: You're just cross because Mike said you have saggy arms.

JEMMA: I have not got saggy arms.

NEIL: Tits then.

SARAH: I think we're being a little rude to our new member, Anton. He's still waiting to find out what ornament he is.

ANTON: Yes please.

JEMMA: Okay I think you would be.
You would be.
A flower in a vase.

The group claps.

NEIL: I'm not clapping that.

JEMMA: I don't think you understand the principle of the clapping.

NEIL: Flower in a vase? That's a lot of cock.

JEMMA: I can't believe you would say cock to me. I was bloody abused.

NEIL: I know you were bloody abused. We all know you were abused. Everybody in the world knows you were bloody abused.

JEMMA: This is about my book isn't it?

MIKE: Oh the bloody book.

JEMMA: Just because I've written a book and you haven't.

NEIL: Yeah tell this guy what it's called.

JEMMA: No because you'll take the piss.

MIKE: He's interested. You're interested aren't you?

ANTON: … Yes?

JEMMA: It's called *Please Don't Tickle Me, Daddy*.

Laughter.

SARAH: Now you really should be more supportive. Jemma's got every right to her book. And if she wants to call Anton a flower in a vase, we accept it.

NEIL: Sorry, / Jemma.

MIKE: Sorry, Jemma.

SARAH: I don't want to have to call time out. (*Does the T-shape with her hands.*)

ANTON: What is time out?

SARAH: It's shh time.

JEMMA: I can do a different one if the flower's not good enough for your lordships.

SARAH: No, Jemma, if you want to stick to the –

JEMMA: No I can do it.

 I think you would be a mirror shaped like a face.

Pause.

SARAH: Well! That's interesting –

JEMMA: Or a key made of glass.

SARAH: Another good one, but –

JEMMA: Or a white room with no –

SARAH: Okay, thank you, Jemma.

NEIL: I prefer Mike's Russian doll.

JEMMA: Oh shut up.

MIKE: Don't tell him to shut up! He's got problems with self-esteem!

JEMMA: So would I if I looked like that.

SARAH: Time out! (*Does the T-shape.*)

Pause.

SARAH: Well, Anton, I hope Survivors has helped you today.

ANTON: Yes. Very much.

The group claps.

SARAH: I like your eyes by the way.

ANTON: Thank you.

The Eyes of Chickens Are Full of Ancient Wisdom

A busy restaurant. CHEKHOV has an empty plate. He's sweating.

MARTIN: What do you reckon?

ANTON: The last one – very hot.

MARTIN: Exactly, you've got the spice hitting you, there's wasabi going on in there.

ANTON: Please, what is wasabi?

MARTIN: It's hot. It comes in a tube. Any Chinese supermarket. It's totally contemporary though it actually goes way back.

ANTON: You have a glass of water?

MARTIN: And the other taste is – you'll never guess – banana. It what this restaurant is all about. When you come to Chow you don't know what you're going to eat. Literally – I mean, we do a blindfold night. So for example we do this deconstructed bacon and eggs breakfast. Bacon and eggs, about as traditional as you can get right? But what we do is wafer thin rashers of chicken breast with a fried pig egg. Lily baby, darling, back *again*? No, I love you *more*. (*Blows kiss.*)

ANTON: Pig egg?

MARTIN: Absolutely. It's kind of crazy, kind of sexy-crazy, the kind of food we serve at Chow is kinda sexy-crazy-happening food for po-mo urbanites. That's what food is now. Food isn't food any more, no yeah? It's changing all the time. You can't stand still because the restaurant-going public is *very* savvy right now, *very* savvy. Which is why if you want to eat here, you gotta pencil in March 2013. They are auctioning reservations – I shit you not – on *eBay*.

CHEKHOV smiles vaguely.

What about the first one? I bet you can't guess what the first one was.

ANTON: Sort of slimey.
Sort of fishy.
I not know. What was it?

MARTIN: Chicken sashimi.
Exactly.
Raw chicken.

ANTON: Raw chicken?

MARTIN: Yes, my friend, raw chicken.

ANTON: Is not a bit dangerous?

MARTIN: Normally I would say yes but this is a totally different ball game. Keira darlin', you lovin' it yeah?

ANTON: Ball game?

MARTIN: Oh yeah, definitely. We're talking special chickens; bred in a special ancient way because in Japan I don't know if you know this but chickens are really respected, you know?

ANTON: Chickens?

MARTIN: (*chuckles.*) Oh yeah. The Japs and chickens, there's some kind of I don't know special communication there. Because I don't know if you've ever looked into a chicken's eyes and there's no reason why you should but if you do because I have it's
Uncanny
Because there's wisdom in there.
Not wisdom, okay not wisdom.
Nah, fuck it, why *not* wisdom?
Because and oh yeah yeah animals don't have (what?) 'feelings'? Or 'the capacity to feel pain'? But I was on holiday out there and I went to this chicken farm in Okayama and – I *know*.
Davina you tart, having a good time? Great.

No, the Japs are really onto something I swear. You want to know about the world, look in the eyes of a chicken. I mean it.

ANTON: Could I *see* one of these pig eggs?

MARTIN: No can do. No strangers in the kitchen.
 I'm right there, Orlando!
 Sorry chum. Trade Secrets.

I Left My Head and My Heart on the Dance Floor

A lapdancing club. Men at tables. The lights are low. Trashy sexy dance music in the background. There are girls dancing on and beside the tables. They are dancing with absolutely no performative energy at all; but the men stretch themselves out in attitudes of lecherous excitement. The effect should be bizarre.

ALEKSANDR enters. He approaches a private office but is stopped by a SECURITY GUARD. He says his name. The GUARD asks for ID. ALEKSANDR produces what we recognise as the document he took from Anton. GUARD speaks on walkie-talkie, receives confirmation and ALEKSANDR is buzzed in.

Pause. Dancing continues, music continues. Guard is watchful. Then a loud gunshot. The office door opens and NICK scrambles through in panic, pursued by ALEKSANDR with his gun.

The men flee, the dancers cower. The GUARD goes for his weapon but ALEKSANDR shoots him. The music stops.

ALEKSANDR: Where is Irina?

NICK: Irina?

ALEKSANDR: TALK TO ME.

NICK: Who are you?

ALEKSANDR: Anton Chekhov. (*To the dancers.*) Keep dancing! Play the music!

The music resumes. The dancers unwillingly resume dancing.

ALEKSANDR approaches NICK. He is talking to him inaudibly. Totally focused. The gun does not waver. ALEKSANDR approaches NICK as the girls dance ands the music grinds away on top.

Yo Soy un Fashionista

An important fashion house. Max, mid-30s, and CHEKHOV are sitting in chairs. A model is standing.

MAX: Yeah and turn around?

 The model turns around.

ANTON: People buy these clothes from you?

MAX: Sure, if we tell them to. (*Laughs.*)
 Okay, Sally babe, we've had enough of you.
 Ugh. That's yours.

ANTON: Is coffee?

MAX: Yes, but it's got milk in.

ANTON: Milk.

MAX: And I'm intolerant.

ANTON: You are?

MAX: Yeah totally.

ANTON: How much this cost?

MAX: The whole outfit? 12K.

ANTON: This is normal?

MAX: Babe, looking great does not cost money.
 This suit came from a charity shop in Shepherd's Bush.
 Cost me fifteen notes. I zhuzhed it up with these badges
 and ironed on, yes *ironed on*, these patches. I've had offers
 in four figures for it but I say nuh-uh. Make your own
 totally contemporary fashion statement, sweet lips.

 Model returns.

 Okay now this one I shouldn't be showing you because
 this is really only going to hit the walks year after next but
 you've got a nice smile so I'm letting you have a peek.

ANTON: It looks very like the last one.

MAX: You kidding me, right? There's a totally different cut
to the bust – because we're going to be *über*-bored of big
tits by then and everything's going super petite. Kind of
sexy little girl look, you know? Trust me darling, eighteen
months time jailbait is back in a big way.
Right now It's all basically an eighties punch, we're doing
a leggings thing, big shirt threw-this-on-this-morning-don't-
know-who-the-guy-was thing, big belts (which I argued
against but was overruled). It's busty, it's boho, it's real
(yawn) which is okay as long as you *totally* subvert it with a
pair of cowboy boots. Thank you Cathy.

The model goes.

What magazine are you from?

ANTON: Magazine?

MAX: No worries. Freelancing's cool.
What do you think of the room?

ANTON: (*Looks about him.*) Um.

MAX: This showroom cost a fortune to do up. Brushed steel
and curved red stained-glass which some people say 'what
are we, Japafuckinese?' and I say, Tokyo is the future,
honey, get used to it.

The model comes in again.

Okay so. In three years, we're going to be very bored
of real and we're going to remember – at *last,* let me say
– that artificial is the funnest thing.
We're going to be seeing a *lot* of fun fur edging. Bags, tops,
coats, shoes. And we're going to bring back, yes, colour!
Neons again, puffball skirts – which so obvious but hey
obvious starts getting sexy next Spring – we're thinking
satsuma, lime green, Tizer colours. And for that extra flash,
we're going right back to tube socks but that is super-ultra
secret and if you tell anyone I will *personally* burn your
house down.

ANTON: You know all this now.

MAX: Sure. You have to order the dyes at least three years in advance, so we have to choose the colours way before that.

ANTON: You are like a wizard. You know what ladies want to wear in the future.

MAX: Let me tell you a little secret.

ANTON: Please.

MAX: Women are
That's okay, Mimi.
(*Confidentially.*) Women are stupid.

ANTON: They are?

MAX: Uh huh. Like real deep down stupid.
Now sure I wouldn't say this if there were any of them here, but between us.
But okay every year we come up with some new type of thing for them to wear. And every year it's something really stupid-looking, ugly, uncomfortable, whatever. Something just kind of ridiculous maybe. And what do they do?
They buy it. They wear it. But it gets better: they want to buy it, they want to wear it.

ANTON: They do?

MAX: Women are giving it all about equality bla bla and they're getting the top jobs and big salaries, deep down they are stupid and we know that and fashion is our way, as men, to remind each other of this fact.

ANTON: You believe this?

MAX: Let me give you an example. Ten years ago we decided – it was a kind of joke actually, over a bottle of wine in Milan – to revolutionise underwear. Knickers out, thongs in. All women must wear thongs – no other underwear is acceptable. And this guy, he's from Moncelli's in Florence, he says to us: and why don't we bring back hipsters at the same time? Low cut, deep waist, hipster jeans.

And we were like no fucking *way*, that is *totally* a step too far. Because you can't have the hipster cut and the thong, it's either one or the other.

But it worked. Women bought both.

And you know what else?

It became sexy.

You see a girl in low-cut jeans and a thong, you get a semi going on, you know what I mean?

And why?

Because the fact that women are so easy to dominate is the biggest fucking turn on ever.

I love your look, girlfriend. Vintage works now.

You want a bit of crank? Bit of Tina? I can go for hours.

Help yourself to the biscuits, they're from Iceland. They're a statement.

Positive Flows of Energy

A large open-plan office.

CHERYL: It's hard to describe.

LYNN: It's sort of, I don't know.

CHERYL: It's hard if you don't know offices.

LYNN: Like architecture but not.

CHERYL: You don't know offices?

ANTON: No.

CHERYL: Because okay because people work in places called offices. Like this one.

LYNN: Okay, and in offices there are problems. But you have to know how to see them.

CHERYL: 'See' (*mimes*).

LYNN: Because the more you know somewhere this is our first principle the less you really see it I mean really see it.

CHERYL: Really, you think you can see but you just don't and I absolutely include us in this because we've all done it.

LYNN: Only now we've been trained so –

CHERYL: We've been yes of course trained so we go into an office and we immediately we know the warning signs.

LYNN: A sick working environment.

CHERYL: Sick as a dog.

LYNN: Sick as a tear drop.

CHERYL: Sick as a Saturday night.

LYNN: It's like this place. They called us up yesterday.

CHERYL: Fucking get the Batsignal out, scuse my French.

LYNN: 'We need help!'

CHERYL: 'Crisis alert! Get me the girls!'

LYNN: 'We've tried everything, girls; team building exercises…'

CHERYL: 'Paintballing in Battersea Park!' / Waste of money.

LYNN: 'We've upped this salary we've dropped those hours.'

CHERYL: 'Help us Lynn and Cheryl, you're our only hope.' / (Star Wars.)

LYNN: We were in here what three seconds?

CHERYL: We haven't even stepped out of the lift.

LYNN: Cheryl nudges me.

CHERYL: Could it *be* more obvious?

LYNN: Aye aye, she goes, aye aye.

CHERYL: It's staring us in the face.

ANTON: What is?

LYNN: Look.

CHERYL: Just look.

Pause.

ANTON: I don't see anything.

CHERYL: Exactly.

LYNN: I mean, hello?

CHERYL: Pot plant?

LYNN: Would it kill them to put a bit of green around?

CHERYL: Organic shapes?

LYNN: Would it break the bank to get in a Swiss Cheese Plant?

CHERYL: A fern! A fucking fern! Scuse my French.

LYNN: We haven't changed it. We're waiting. We want them to work it out for themselves.

CHERYL: Give a man a fish and he eats for a day.

LYNN: *Teach* a man to fish and he eats for ever.

CHERYL: Only if he likes fish, obviously.

LYNN: Who doesn't like fish?

CHERYL: We've got that on the wall in our office.

LYNN: (Not 'who doesn't like fish?'; the first bit.)

CHERYL: So we're not out the lift and we've spotted problem numero uno. Problem numero – two – takes a bit longer…

LYNN: Like ten seconds?

CHERYL: I mean it's taking sweets from babies really but they called us in.
We don't tout. We don't have to.

LYNN: Have a look.
There's a glaring mistake.

Pause.

CHERYL: You'll kick yourself.

Pause.

LYNN: I'll give you a clue. It's big.

ANTON: I'm sorry…

LYNN: The reception desk?

Pause.

ANTON: I don't understand.

CHERYL: I mean it's *square! Hello?*

LYNN: I mean they might as well shut up shop and go home frankly.

CHERYL: It's the positive energy. It wants to come in but they're stopping it.

LYNN: It's trapped. Positive energy wants to get in but it can't.

CHERYL: 'I want to help you but I'm trapped behind this desk!'

LYNN: See, there are two types of energy –

CHERYL: Positive and negative energy.

LYNN: Like plus and minus. In maths?

CHERYL: But we don't want to bog you down in science.

LYNN: And positive energy is warm, it's energizing in a good way. It's positive, basically. People feel good when there's positive energy around.

CHERYL: It's like chocolate but more so.

LYNN: If it were a colour it would be a soft sparkling orange.

CHERYL: Like Tango if you have that in Russia.

LYNN: But negative energy –

CHERYL: (*Sharp intake of breath.*)

LYNN: That's a different kettle of fish.

CHERYL: When you've got negative energy, it's cold, people are unfriendly. It would be more blue (like After Shock Citrus I don't know if you have that in Russia). Negative energy is blue and it's all angles (*Demonstrates with her elbows.*)

LYNN: Angles exactly because that's the problem with negative energy. Positive energy moves in gentle curves and flows but negative energy can go round obstacles.

CHERYL: So if you put a fucking barrier in the way, scuse my French, you put a square desk, the *negative* energy goes 'okay I'll just nip round that', the positive energy is trapped. It can't flow. There's not enough room between the lift and the desk for it to get a real curve on it.

LYNN: So what do you do?

CHERYL: You do two things: first what we call opening the cage – you create vents for the negative energy to drain away.

LYNN: Open a window, say.

CHERYL: Paint a wall lilac because that neutralises negative energy.

LYNN: And secondly, put more curves in.

CHERYL: Get a curvy front desk – let the positive energy in, for fucksake, / scuse my French.

LYNN: You want flows, lines; change the arrangement of the desks – do you need a straight line between them? No.

CHERYL: What about an arc?

LYNN: Simple, graceful.

CHERYL: A fucking arc; it's not hard.

LYNN: It's not rocket science.

CHERYL: It's not brain surgery.

LYNN: It's ordinary common sense.

ANTON: (*Smiles vaguely.*)

CHERYL: We're giving away our secrets.

LYNN: You're very easy to talk to.

CHERYL: He's a good listener.

LYNN: No you are.

CHERYL: We wrote a book. *Open-Plan Minds.* It's a guide to freeing positive energy in the contemporary office environment. It's available in all good bookshops.

LYNN: It's good to meet a fellow writer.

You Know What I'm Saying?

MARCIA: Okay.

Hi. Welcome to my crib.

This is my *porch* which I got them to build because I'm a real like homely girl and some nights I like to hang out on the porch, with my girls youknowwhatImsayin?

ANTON: No.

MARCIA: Sure cuz it's a girl thing, youknowwhatImsaying? We're all like get all the make up you know like pile it on boo you got it going on one time and it's a uh-uh You-Want-Us-But-You-Can't-Touch-Us thing, youknowwhatImsaying? Going past in their piece of shit car they wanna *be* on this porch, they wanna be drinking beers with the Girlz and I'm talking GirlzwithacapitalG cuz that's the deal, youknowwhatImsaying? (*Sung, in an R&Bish warble, with the sideways head thing.*) 'You think U iz getting one / but U iz getting three / Take a look at me / Can U take it?' And you see the look on these bruthas' face yo, this ain't no fantasy bro', got the booty here yo, wassamatter? Ain't seed three bitches befow? got ba-donka-donk threeways, right on the plate, but they can't walk it, damn straight they can think it but sucka can't live it; they're walking and walking and we're laughing and laughing.

ANTON: I'm sorry. I don't have the slightest idea what you are talking about.

MARCIA: I hear you bro and I'm saying it to you. There's a bond there youknowwhatImsaying? Tuffa than lead yo. Cuz I'm packing, I'm in the field, and Marcia is Mar with the CIA. Cuz when I'm with my girls you better believe I'm with my *girls* you know what I'm saying? That's what the music's all about, star, 'Gotcha Own Wingz' I'm not talking to the guys, nuh-uh, I'm talking to the laydeez, you gotcha own wings and no brutha gon' take yo wings away. We say: guys,

You can *try,* but you gonna *fly,* youknowwhatImsaying?
Let's go inside.
This is my kitchen. I love black, it's an African thing. All
the surfaces are marble – guaranteed black. Come from
China, G. I'm a great cook. I'm the Michelin Gangstar.
This is my fridge. It's dope, youknowwhatI'msaying? It's
got three doors and an icemaker. But nah don't look in cuz
I ain't got shit in there right now.

ANTON: Why you have shit in fridge?

MARCIA: No star I got none, like I said. Okay and through
here is my gym. This is got all the coolest stuff. I got abs
machines, lower *back* youknowwhatImsaying?, that's a
stretch ball, running machine; this is my crosstrainer. I love
this machine cuz I can keep my dog with me on this. I got
the cutest damn lapdog.
I am so out of shape, I better get off this.
I don't know how the damn thing works.
It's a great gym.
I got three of everything. Yoga mats.
When I'm with my girls, we might wanna come down
here and work out. You know how much that picture wud
go for? 75K no shit. Me and my black sistas working out,
that's a picture for ya.

ANTON: …you are black woman…

MARCIA: I'm saying it's a black thing, yo. But I like to keep it
to myself, youknowwhatI'msaying? Got the photographers
at the gate, s'all wack, can't do nuthin by the window and
they all arksin': you do this, girl? you do that? and I'm
come back atcha with this:
Do you want the *history?*
Or do you want the *mystery?*
YouknowwhatImsaying?

ANTON: I want the history.

MARCIA: Not me bro. I don't got that history thing.
I just wanna be home. I'm a homegirl.
I got my own *life,* you feel me?

I just wanna sit around in my crib, waiting for the girls to come around.
I got sixty-five rooms to wait in, star.

I am Anton Chekhov

The lap-dancing club. Everyone has now fled, but NICK has been tied to a chair. He is bruised, bloody, scared and whimpering. ALEKSANDR stands above him with a gun. ALEKSANDR is still holding the ID.

ALEKSANDR: Where is she, Nick?
(*Violently, throwing Chekhov's papers at him.*) WHERE IS SHE?
Where is Irina?

Subsides.

How did we become these men, Nick?
Tell me when it happen.
When you say, I will be in this world. I will live a bad life.
Don't fuck me about, Nick. You fuck me about, nothing good happen.

Pause.

You remember the first time you hold a gun, Nick?
Surprise how heavy. How cold. That bullshit. When you pull trigger, the bruise that spread in your hand. Talk to me, Nick. Tell me where she is.

Pause. He smacks Nick in the face with the butt of his gun. NICK yells in pain.

That is right, Nick. And it's going to get worse. Tell me.
Tell Anton.
Tell your Uncle Anton where is Irina.

He cracks him in the face with the gun once more.

Tell Anton Chekhov.
Don't make me a worse man than I am now.
I am not this man you see before you.
Give me a choice, Nick, to be the man I want to be.
You have five seconds.
5. 4. 3. Help me Nick. I am not like this. 2.

Drown them with music.

The Search for Chemical Weapons

A police station. CLAIRE, the police community support officer, and PC ASTON from the park. Maybe a map with pins in.

CLAIRE: The problem we're finding, Nicky, is that there's no pattern to what he does. He visits a restaurant and then he shows up at the home of some pop star; he's in someone's office then he's on a building site on the other side of town. It's very random, Nicky, and I have to say that from a police investigation perspective, random is not good.

PC: There's no pattern. He's all over the place. He doesn't seem to be headed in any particular direction.

CLAIRE: Which is a problem, Nicky, you see, because we don't know where he'll be next. Soon as we think there's a pattern and he's, say, heading for a bank, he's just as likely to end up in a church.

INSERT:

CLERGYMAN: You see God is not a – I don't know – old bloke with a white beard sitting on a cloud.

ANTON: No, I not think so.

CLERGYMAN: God is more like a mountain stream. This is what we have to get across. He's like a beam of sunshine. Or the smell of a flower.

ANTON: Really.

CLERGYMAN: Something nice like a rose, obviously. Not a smelly flower like an orchid.

ANTON: No, no.

CLERGYMAN: In a way He's all flowers. The biggest bestest bunch of flowers you ever saw. Wrapped in the cellophane of revelation with a little sachet taped to the side that says 'eternal life'.

ANTON: Ah.

PC: I have to ask you this, Ms Chalker: are you, in fact, in communication with your uncle?

NICOLA: No.

PC: We'd understand if you were.

NICOLA: I'm not.

CLAIRE: It would even be better if you were, so we could bring him in nice and quietly.

NICOLA: Bring him in? He's not in trouble is he?

PC: In trouble? He's got no documentation or permission to reside. He's on the run following a violent assault on two police officers in a public park. He has proven links with a Russian gangster and he has a rare strain of tuberculosis bacteria in his system. Your uncle is a dirty bomb, Ms Chalker. Yes he's in trouble and the sooner you hand him over to us / the sooner we can end this.

NICOLA: I told you: I ain't seen him. How do you know he's even in the country?

CLAIRE: His photofit is at all the ports and airports. And anyway, Nicky, he seems to have set up a Twitter account.

INSERT:

TheRealChekhov Hello. I am eat a sandwich.
October 25, 11:37

TheRealChekhov I audition for Britain Got Talent. I do impression of Maxim Gorky. They say no :-(
October 28, 3:05

TheRealChekhov Today I sit under tree and cry and cry and cry.
November 1, 8:56

TheRealChekhov OMFG I ♥ Justin Bieber. LOLZ.
November 3, 9:15

TheRealChekhov This ground. This air. This sun. This moon. The same sun? The same moon?

November 4, 6:22

PC: Not showing up on CCTV footage. Nothing from hostels or homeless shelters.

NICOLA: What about clubs and bars? He might want to go out for the night.

PC: I think he'd look pretty conspicuous.

INSERT:

Flash up a very short sequence. House music, a club, CHEKHOV on the dance floor, vigorously throwing shapes.

NICOLA: Do you think he might have met someone?

CLAIRE: What, do you mean, Nicky, in a professional sort / of a way?

NICOLA: No I meant in a personal kind of a way.

CLAIRE: Well it's possible but that's not the angle we're pursuing.

NICOLA: I mean, I don't think so. I really don't think so. He wouldn't. Surely.

But he does have nice eyes.

Reality 2.0

JAMES: The thing people don't get about the Internet is
that everything is new, the past is dead, nothing is real,
everything's good, nothing lasts, it's all changing, there's
no up, there's no down, no one's rich, no one's poor,
nothing is better than anything else, yeah? You've read the
magazines, you've read the blogs, they call me a 'genius'.
No. Wrong. Epic fail. Drop it in the wrongbox because the
Internet is not about being a genius somestuff because am I
a genius? Whatever, it doesn't matter. Look, you're a writer
yeah? / I thought so. I never forget anything.

ANTON: Yes.

JAMES: It's kind of my thing. What was I saying?

ANTON: Being a genius.

JAMES: Bla bla bullshit. Because they call me a genius and
maybe I am, Jesus I don't know. Because I 'innovate'?
Because I am 'creative'? Well yeah, *but* – yeah? Cos do
you ever ask yourself what creativity is? No, course you
don't, no one ever does. So let me tell you: being creative
is coming up with stuff.

ANTON: I see.

JAMES: And how do you do that? How do you come up with
stuff? Please. Have fun. Can we? Just? Because when you
have fun there's oxygen going to the brain – 'and now the
science bit' I know, I know *but* – I mean, when did you last
have fun?

ANTON: 1904.

JAMES: Tell me about it because they show me stuff, they show
me bad tech, somestuff, they show me 3D Internet and I'm
like meh, I'm like, excuse me? 3D? Didn't we do that in
the like the seventies somestuff? Come *on*.

ANTON: I think I see.

JAMES: Hey. I'm not anti-3D because you know what? 3D is all around us. And you say: yeah, that's reality. But I say: reality's good but it can be better. The thing with the web is it's not the same sad old bullshit. It's a different thing. Nobody gets this. Because people are all 'what ever happened to personal human contact?' somestuff. Here's the deal. Web 2.0 is a whole new way to breathe. We don't want books; we don't want to be told a story, forget it, that's gone (*mimes shooting a kneeling prisoner execution-style in the head*), bye bye, that's not the world now. You make your own book, you make your own music. You *are* your own book, you *are* your own music. Literally. Why not?

ANTON: What do you do?

JAMES: I make things happen. I build web presence. I innovate digitally. I think the new media. I design Apps. Let me fire one up for you.

ANTON: Apps – ?

JAMES: Okay look at this, just shows you the room right?

ANTON: Okay.

JAMES: Hit this button and now what have you got? Look, the app starts tagging everything in the picture. See here? Point at my laptop, it's telling me that this is a MacBook Air, 13" screen, starting at £1,378, click on that button to be taken to a range of selected stores. Look at my shirt, what does it say?

ANTON: 'Alexander McQueen, Stone Textured Stripe Shirt, 100% cotton, concealed buttons, starts at £380.00.'

JAMES: Amazing. It knows the value of everything. With this app you can buy literally anything you see.

ANTON: I understand.

JAMES: In Web 2.0, seeing isn't enough. It's about tags and dialogue and flexibility and interaction and being non-fucking-linear for once in your life and its social networks and it's now and it's super-now and it's having information

at your fingertips because what's money? Information is the new money. You see Wikipedia, I see money. And it works with people too. Point it at me, what does it say?

ANTON: 'James Ward, Internet guru, futurologist, Genius'.

JAMES: Yeah whatever somestuff. And if I point it at you

Beat.

Okay well you haven't made your mark yet but when you do – and you will because I have a feeling about you – and when you do your information will be in the cloud waiting to stream down to his smartphone, her smartphone, everybody's smartphone, everybody gonna know your name.

ANTON: This is… a good thing…

JAMES: You get this stuff. Most people don't. You're good to bounce ideas off. I could use someone like you.

ANTON: Thank you.

The Middle of Everything

Bell dings. Lights up. Woman in her thirties.

VALERIE: I'm Valerie.

Hi.

I'm an actress. You probably don't recognise me. Though I did do a *Doctor Who* last year which… No? Okay, no reason why you should.

7.8 million but so what?

37.4% audience share but who cares?

You're more likely to recognise my voice because I'm most well known for my voice-over work. No, it's surprisingly skilled. The key thing about doing voice-overs is you have to make everything sound sexy. Whatever it is. You name it.

Well maybe not potatoes.

No okay even potatoes.

(*Sexily.*) 'Hot melting butter. Salty skin. You know you want a potato…'

What do you think?

Bell dings.

Oh

Lights down. Lights up. Woman in her twenties.

SELINA: No I do like guys, definitely, but more as like mates, you know. I just feel more comfortable like that. Smoking and fags and stuff. I just sort of freeze up when there's anything else going on you know what I mean? It's not that I'm lesbian or nothing I'm just not very good at people wanting to do sex with me. Cos okay my friends say to me, like, get a life or whatever but I always think, I always think, I always think, I don't want the sort of life you can *get*.

Bell dings. Lights down. Lights up. CHEKHOV.

ANTON: I woke up. I don't know when. I don't know where I am. I don't know what it means. I don't know what has happened while I slept. I wish I was ill again. I wish I had

died in Badenweiler. I wish this meant something. I wish I understood things. I wish people were joking. I wish I felt rain in my eyes and I wish I felt snow in my heart and I wish I could find a white place where I could disappear.

Bell dings. Lights down. Lights up. A lapdancer.

KELLY: Please listen carefully. I haven't got much time. I may have been followed.

I know who you are. You're Anton Chekhov. Don't look round. I've been looking for you.

Please let me speak. I'm sure you're not a bad man.

I work at the Panther Club. Nick's club. I wasn't working – that night – but the girls told me what happened. I haven't been back.

I know where you can find what you're looking for.

I know what you've been searching for, who.

You will find what you want at this address.

But then please, leave us alone. I beg you, Mr Chekhov.

Bell dings. Lights down. Lights up. Man in his twenties.

BOB: Sometimes I want to stop everything. Like I wish there was magic so I could just stop everything, wherever it was. And when it was paused, and not like VHS (*wobbles demonstratively.*) but a perfect pause like a DVD pause (*he freezes.*), I would get a knife and cut a slash down the middle of everything and the lights would be bright behind it all and I'd step through and disappear. Shit I'm being intense again, aren't I? The woman back there said that I made her uncomfortable. Do I make you …

Bell dings.

Uncomfortable?

I'm Here For You 24/7

Telephone call. Not necessarily with telephones.

CLAIRE: Okay, there have been some developments.

NICOLA: Have you found him?

CLAIRE: Not exactly but, okay, let me bring it up on my screen because I do want to get my facts straight. Here we are. Okay, Nicky, so: reports came in three days ago of shots being fired in the Docklands area. We've been searching premises along the riverside and they found this private club. Gentleman's club sort of thing.

NICOLA: Right...

CLAIRE: And inside it's deserted. Place has been shot up. Bullet holes in the ceiling. There's a security guard dead on the floor and the owner's in a chair, tied up, unconscious, badly beaten up. Blood all over him.

NICOLA: I don't get it. What's this got to do with me?

CLAIRE: Well we got the owner to hospital and once he'd revived enough to make his statement he says that the intruder who burst in, tortured him, terrorised the girls, and murdered the guard was Anton Chekhov.

NICOLA: You're kidding me.

CLAIRE: I'm sorry, Nicky.

NICOLA: But he wouldn't do that.

CLAIRE: I'm afraid we found ID belonging to your uncle on the premises. I've got it in front of me. There really is no doubt.

NICOLA: I don't fucking believe this.

CLAIRE: I know this will come as a shock and I am here for you 24/7, Nicky, you know that.

NICOLA: So what now?

CLAIRE: Well, the victim says your uncle is looking for a girl.

NICOLA: A girl?

CLAIRE: And we have an address.

It's A Totally New Concept in Light Entertainment

JESSICA: No, no, because yes yes you remember Celebrity Fat Club –

CRAIG: Fit Club, Jessica. ('Fat Club'!)

JESSICA: Fit Club because (was it? Bloody hell Craig because I've been saying Fat Club all over the place; (*Hand over mouth.*) I think I said Fat Club to the BBC.)

CRAIG: Honestly, it's not an issue.

JESSICA: Okay I think because (I am so embarrassed) I think those shows are just voyeurism. I do. Because you know sometimes I think Sky would just like to show complete hardcore, you know

CRAIG: Dildo-cam, you know, really gynaecological –

JESSICA: And like *I'm a Celebrity* I just don't get the whole Bushtucker trial thing.

CRAIG: This is a totally *different* thing.

JESSICA: It's a way of *punishing* I think celebrities for (what?) for being a celebrity and you think, who made them a celebrity? Who do we think they are famous in the minds *of?* Do you see what I mean? And we watch them eat a a a a a witchetty grub

CRAIG: Eat a a a a camel's testicle? I mean come *on.*

JESSICA: So it's important to us to say that *Helping Hand* is a show about reaching out and really as it says helping

CRAIG: Because we all need a little help.

JESSICA: Really helping people who need help.

CRAIG: Most edutainment has the educational value of a a a fuck knows you know what? an egg, something, but this is real.

JESSICA: Don't let Jamie Oliver hear you say that.

CRAIG: Ha ha, no exactly actually.

JESSICA: Because this is real and it's also good, it's doing good deeds if you like.

CRAIG: This is real and it's good and it's earthy. It's real and earthy. It's dirty and sexy and it's real.

JESSICA: On the development group we have a priest *and* a rabbi *and* a muslim cleric (not an evil one, a nice one, you know) so…

CRAIG: We're making doing good deeds sexy. So shoot me.

JESSICA: In *Helping Hand* people nominate their partner or spouse or colleague as needing help. So like they're drowning in paperwork say.

CRAIG: Some poor bastard has a difficult boss.

JESSICA: They have out-of-control children.

CRAIG: A woman who is morbidly obese.

JESSICA: (Would we do morbid obesity?)

CRAIG: (Well I'm thinking if it's medical / not just –)

JESSICA: (Yeah, yeah.)

ANTON: And what do you do?

JESSICA: Well basically, we pay them a bit of attention because everyone I don't know if you agree with this Craig but I think everyone needs a bit of attention.

CRAIG: I agree with that 100%.

JESSICA: What we do is okay we video them –

CRAIG: Secretly –

JESSICA: Which in itself is a kind of attention.

CRAIG: It's like we're a father-confessor. Or a witness.

JESSICA: Maybe we're just good listeners. Maybe that's all we do. (*Open-palmed gesture.*)

CRAIG: But we video them for a couple of weeks and then we confront them.

JESSICA: We show them the evidence; we say, 'You need help. You need – a Helping Hand'.

CRAIG: (I say 'we', it's actually Abi Titmuss.)

JESSICA: And because we're into the third series now they recognise the title which helps.

CRAIG: Though in January we did this preshoot for this guy and his wife says he's got problems with money kindathing.

JESSICA: Because we're planning to send in Duncan Bannatyne or whothefuckever.

CRAIG: And what we eventually get is video proof that this guy is probably in financial ick because he's got another woman.

JESSICA: It was a real tough one, I mean a real tough one.

CRAIG: We had to make a judgment call and if you show me a guy who likes making judgment calls I'll show you a liar and I know that's strong but it's what I believe.

JESSICA: But we pretty much make the judgment call and we kind of thought the wife–

CRAIG: Belinda.

JESSICA: Listen to me: 'the wife'! We just thought that *Belinda* (thank you) just wouldn't cope with it, so we kept it to ourselves.

CRAIG: And fortunately nothing came of it, if you see what I mean.

JESSICA: We wiped the tapes virtually. I mean not literally but mentally.
Though it feels like a bit of a compromise.
Morally I mean.
Which is what this show I guess is trying to address would you say Craig?

CRAIG: I think what Jessica's saying is that we're trying to
show that life is about compromises and this show –

JESSICA: No Craig actually sorry no what I mean what I mean
is that in life because yes sure life is – what did you say?
– compromises but what I'm saying is that this show is a
chance is a is a is an opportunity to do something good.
Just good. Because compromises sure, okay, but when your
life is made up of compromises, you end up, I don't know
and I'm not speaking personally, but you sometimes you
wake up and you think how did I get here?

ANTON: Yes.

JESSICA: How did I end up like this?
Living this life?

ANTON: Yes.

JESSICA: You know, every compromise.
I sometimes wish I could meet the sixteen-year-old me and
say, Jess, there are forks in the road.
It will seem to you like these decisions are hard. But
they're *not* hard Jess and deep down somewhere you know
they're not.
Because I have made bad decisions, yes I have, and look at
me now. Money and car and a flat in Borough yada yada
but you don't want to grow up to be me, Jess.

I'm not ashamed to say I've stood in the street crying for
no reason
Every little compromise when all you want to do is
good, do something good for someone, not for yourself,
something purely good, purely for someone else.
And so of course you find yourself you know on your
knees let's say, in someone's flat at three in the morning,
saying please cum on my face.

CRAIG: I beg your pardon?

JESSICA: Cum on my face. Please. I mean I'm not saying I've
said it, that I *would* say it even, I'm just *saying*.
If you found yourself.

Three in the morning.

On your knees on a stranger's floor.

Calling him daddy, whatthefuck, you know begging him, in that voice, that voice he likes, you know he'll like, begging him to to to as I said cum on my face begging him or you're saying I'm a dirty slut and I want you to fuck me in the arse because I'm just saying the world is a rotten fucking nightmare of a place, and life is just death isn't it? Course it is, and we know it, we all know it, and sometimes you look about you and you see the way people treat each other, the way they talk to each other, and you know you don't mean it and you don't know when it happened but you have started to treat people like that too, and in fact you can't remember being kind, you can't remember the last time you were kind to another person, and you start to wonder if you can do it any more, if you physically could do a kind thing for someone,

Because how deep in the soul has this darkness got?

You think I'm lost, I'm buried, I'm lost in the earth

And you think to yourself; is this the world? Is this actually it?

You want to start again, to tear it apart and step through, but you can't, you know you can't, and so you think maybe – I don't know but maybe – on that floor, whatever, you think if I can make this one person for one second truly truly totally happy I can make this, all this, I can make all this right again.

Long silence.

CRAIG: And that's very much what *Helping Hand* is all about.

Northern Lights

OLGA KNIPPER is hovering in the Northern Lights.

ANTON: Olia?

OLGA: Anton.

ANTON: Where are you?

OLGA: I'm in the Northern Lights.

ANTON: What are you doing there?

OLGA: Watching you.

ANTON: How am I doing?

OLGA: Not well, my Anton.

ANTON: I have missed you.

OLGA: And I you, my love.

ANTON: What can you see from there?

OLGA: Just you.

ANTON: Why didn't you let me die?

OLGA: And take you back home? Do you know what was
 happening there?

ANTON: No.

OLGA: It doesn't matter. It's not important

ANTON: I would rather have died than to see this.

OLGA: I would rather have died than to let you die.

ANTON: I'm not ready for any of this.
 It's like you have cut off my eyelids.

OLGA: Anton, that's a horrible thing to say.

ANTON: Well…

OLGA: Anton. I thought it would interest you. You a doctor
 who could gaze at the worst sores and peer into swollen

wounds. At the medical school, as your friends fainted
around you, you stood to watch Zakharin and Ostroumov
cutting open the bodies of Muscovite criminals.
I've seen you staring at your own blood with a glass.
You were unmoved by the suffering of friends.
You grew up with death around you and you were never
serious, never serious, my Anton.
I would have to remind you. No jokes, Anton, I would
write.
You mocked all religious feeling. You laughed at Pavel
Yegorovich's fear that he would go to hell and you called it
childish.

ANTON: I did, I know.

OLGA: I am borne on the back of light.
The trails turn and the Arctic lights will swing me away
from you, Anton.
The Arctic light is so white my darling, my dear.
The whitest light. You feel your face burn with it.
Feel it burn away.
Skin first, then the hair, it shines and shines.
Then the lips.
Soon you are just your eyes.
I feel sure you would like to be just your eyes, Anton.
And then, even they go.
You'd like it here.
You'll like it here.

Number One on the Hit Parade

A bare room. A bed. A television on which a hardcore porn video is playing. A towel on the bed. Pink lights. CHEKHOV is sitting on the bed, vacantly watching the porn video. There is a pause. A WOMAN enters. She stands smiling.

Pause.

IRINA: Well here it is.

ANTON: Okay.

IRINA: This is number one in the hit parade. The schoolgirl.

ANTON: Gentlemen ask for this?

IRINA: Gentlemen? I guess. Yeah they ask for this.

ANTON: What is this mean?

IRINA: Schoolgirl. Young, you know, all innocent, oh Mr (whatever), have I been a naughty girl? Are you going to spank me, sir?

ANTON: Schoolgirl wear this?

IRINA: I don't think schoolgirl wear suspender belt but sorta.

ANTON: You are not schoolgirl.

IRINA: No, it's a fantasy service.

ANTON: These men like to make sex with young girls?

IRINA: (*Thinks.*) No. Hm. I don't think so.

Pause.

So. What you wanna do?

ANTON: And what you do?

IRINA: Whatever. Oral, covered or uncovered, uncovered's extra: A Levels, domination, restraint, role play. Vanilla also, if you want. It start at twenty-five for hand relief.

ANTON: What is your name?

IRINA: Sally.

ANTON: You are not from Russia?

IRINA: No. I am English Rose. What you want to do?

ANTON: You choose please.

IRINA: No, you got to choose.

ANTON: No, please, whatever is most popular.

IRINA: I don't understand.

ANTON: Just please. Whatever they usually ask for.

IRINA: Well, with this, I guess we can start with role play.

ANTON: Please.

> *Pause. She turns round.*

IRINA: Ooh sir, I dropped my pencil. (*Bends over.*) Are you looking at my panties, sir? I am such a naughty girl, sometimes, sir. (*Giggles.*) Do you like what you see, sir?

> *Pause.*

Usually a guy touch me by now.

ANTON: Please. I want to see what happens.

> *Pause.*

IRINA: I've always liked you, sir. A big sexy man like you. Hope you're not too big for me, sir.

> *Pause.*

I feel stupid.

ANTON: Why for you are feel stupid?

IRINA: If you're not going to do anything.

ANTON: I just listen.

IRINA: You can't just listen.

ANTON: Please.

IRINA: It humiliating. You want make me feel like shit?

ANTON: No. No.

IRINA: Well you do make me feel like shit.

ANTON: I not understand.

IRINA: You not just watching. You are here. You think I do this
 if no one is here? Watching is bullshit. You tell me what
 you want or I hit panic button.

ANTON: Please.

IRINA: What?

ANTON: Tell me something.
 Talk to me.
 Tell me what has happened.

IRINA: What has happened?

ANTON: I want to know what has happened to the world.

IRINA: Nothing. What do you mean?

ANTON: I want you imagine I am asleep for 100 years.

IRINA: Why?

ANTON: I just need to know what happened.

IRINA: This is a role play?

ANTON: Maybe.

IRINA: You want history lesson?

ANTON: Yes.

IRINA: Huh.
 Schoolgirl teach the teacher. Pretty funny.

ANTON: Please.

IRINA: Where you want to begin?

ANTON: 100 years ago.

IRINA: Okay.
 There was a war.
 A big war. Lots of men die in mud.

Germany, France, Italy I think.
People say never again.
This okay?

ANTON: This is good.

IRINA: Then there is a revolution in Russia.

ANTON: Revolution?

IRINA: Revolutsiya.

ANTON: You say you are English.

IRINA: Ukrainian.

ANTON: You speak Russian?

IRINA: N'emnoga.
[A little.]

ANTON: Please try. Tell me what happened.
While I sleep something bad happened.
The world was not like this.
No one will tell me what happened.

IRINA: Proshla voina, bol'shaya voina.
Milliony smertyei.
V Rossii sluchayetsya revolyutsiya
Blagaya idyeino, ochen' bystro stanovitsya chornoi.
Milliony smertyei.
V Germanii pravyit plokhoye pravityelstvo
S plokhimi nameryeniyami, ochen bystro stanovitsya vsyo
khuzhe.
Milliony smertyei.
Teper' v mirye tol'ke Coca-Cola i McDonalds
Vsye svobodni.
Milliony smertyei
Milliony golodnykh
Milliony bednykh.
Govoryat, eto estestvennyi khod cobytii no ya nye
uvyeryen.
Govoryat, nichyevo nye podyelat', no ya ne uvyeryen.
Oni ustraivayut kontsert Queen i Phil Collins.

Ya nye dumayu chto eto chto-to menyaet.
Nyeckol'ko lyet spustya gorstka terroristov napravlyayet samalyoty v
World Trade Centre v Ameriki i vsyo stanovitsya uzhasno.
Vsye khotyat tvorit' dobrye dyela no vsye stanovyitsa glupymi i myerzkimi
I milliony smertyei, milliony golodnykh, milliony grustnykh.

[There was a war, big war.
Millions die.
Then, in Russia, there is a revolution
This starts good, goes bad very quickly.
Millions die.
Then in Germany, there is a bad government.
This start bad, gets worse very quickly.
Millions die.
Then the world is taken over by Coca Cola and McDonalds
Everybody is free.
Millions die
Millions hungry
Millions poor.
People say this is natural but I don't know.
People say there is nothing you can do but I don't know.
They do a concert with Queen and Phil Collins.
I don't think that changes anything.
Then, a few years ago, terrorists flew planes into the World Trade Centre in America and everything becomes shit
Everybody want to do good things but everyone becomes stupid and nasty and millions die, millions hungry, millions sad.]

Anton weeps.

ANTON: Spasibo.
[Thank you]

IRINA: Mnye ochyen' zhal'.
[I'm sorry]

A door bangs open, off.

ANTON: Shto eto?
[what was that?]

They listen. Footsteps approach. The door opens slowly. And ALEKSANDR is there.

IRINA: Mr Polzin.

ANTON: Hello, Sasha.

A moment.

You have my passport?

ALEKSANDR: What?

ANTON: You bring me my passport?

ALEKSANDR: What are you doing here?

ANTON: I talk to this / lady.

ALEKSANDR: Don't touch that.

IRINA: I –

ALEKSANDR: Get away from there.

IRINA moves away from the panic button.

ANTON: Is problem, Aleksandr?

IRINA: You know this man?

ALEKSANDR: I have business with this girl.

ANTON: Sally is friend of yours?

IRINA: My name is Irina.

ANTON: Irina, okay.

IRINA: Why you come here? I work for Nick now.

ALEKSANDR: I have spoken to Nick.

IRINA: What you do to him?

ALEKSANDR: We have a problem; we discuss it.

IRINA: What you want?

ALEKSANDR: I'm here to bring you back.

IRINA: I am not coming back.

ALEKSANDR: I'm so sick of this shit.

ALEKSANDR produces the gun, wearily.

Put your things in a bag and come with me.

IRINA: Oh fuck oh fuck.

ANTON: What you do?

ALEKSANDR: I am surprised at you, my friend.

ANTON: Surprise at me? Why for surprise?

ALEKSANDR: I thought you were better than this.

IRINA: You can't do this. You can't do this.

ALEKSANDR: You got a choice. You come with me or I shoot you in the leg, you choose.

ANTON: I not understand.

ALEKSANDR: You stay out of this, my friend. Three seconds.

IRINA: Fuckfuckfuck.

ALEKSANDR: Three.

IRINA: Help me.

ANTON: What I can do?

ALEKSANDR: Two.

IRINA: He is a bad man.

ALEKSANDR: One.

ANTON: Sasha. Please.

ALEKSANDR: Zero.

He pulls the trigger. The gun clicks emptily. Pause.

Yeah. I'm all out.

He lowers the gun.

IRINA sees her chance and runs from the room.

Then, after a silence:

It's true, Anton Chekhov. I am a bad man.

ANTON: You are?

ALEKSANDR: Yeah. Terrible man.

ANTON: Oh.

ALEKSANDR: I was a good kid. But I am a bad man. Little steps, bit by bit. Bad things, bad things. I don't know.

Silence.

ANTON: In Yalta, sometimes the winter sun is brighter than a summer day. So cold you think you will cry but the light, you walk about in this light for one day – in the market, through the park – it burn the colour from your eyes. Colours all fade; everything pale, more pale. Then you just see shape, see outline of people and trees. Towers thin like needles. The face of the people they so white now you cannot see skin, but only an eye, a mouth. Then not even eye and mouth. Everywhere now is white. The ground white and empty. The sky, the sky is white. A white place. Like you have cut a hole and stepped through.

Pause.

ALEKSANDR: And what's your point, Anton Chekhov?

ANTON: I not know.

From outside. Loudhailer.

POLICE: Anton Chekhov! Anton Chekhov! This is the police. We have the building surrounded.

ANTON: What they say?

ALEKSANDR: Oh shit.

ANTON: They talk to me?

POLICE: Anton Chekhov! This is the police. We know you're in there. Come out with your hands above your head.

ANTON: We should go.

ALEKSANDR: Let them wait.

ANTON: Why?

ALEKSANDR: See what they want to do.

ANTON: But they tell us to come out.

POLICE: Anton Chekhov! There is no other way out of this building. Come out with your hands above your head and no one will get hurt.

ALEKSANDR: They think you are a bad man too.

ANTON: Why they think this?

ALEKSANDR: Because Anton Chekhov has done many bad things.

NICOLA: (*Loudhailer.*) Anton. This is Nicola. You saw me in the hospital. I held your hand.

ANTON: I know this woman.

NICOLA: I don't know what you've done and why you've done it but please, Uncle, it's got to stop now. You've got to give yourself up. Please.

ANTON: They want me.

ALEKSANDR: No, they want me.

ALEKSANDR raises gun, lowers it.

ANTON: They say my name.

ALEKSANDR: Yeah but it's my name.

ANTON: Your name is Anton Chekhov?

ALEKSANDR: It's complicated.

ANTON: Why?

ALEKSANDR: You wait here. I go see them.

ALEKSANDR leaves. Long pause. CHEKHOV watches the porn video distractedly. From outside we hear:

POLICE: Anton Chekhov, put your hands where we can see them.

Pause.

Put down your weapon. Repeat: put down your weapon.

ALEKSANDR: MUTHAFUCKAS!

A volley of shots is heard. Body to the ground. Commotion. Police shouting, sirens, voices on radio, woman screaming.

CHEKHOV: Shto eto znachit
Shto eto znachit
[What does it mean?
What does it mean?]

Blackout.

Acknowledgements

Vladimir Nikiforov, Noah Birksted-Breen and Astrid Thompson between them translated the various bits of German and Russian. Many thanks to Chris Megson, Rebecca Ferguson, Mike Punter, Linda McLean, Jackie Bolton, Mel Kenyon, for their careful reading and generous advice. I'm indebted to David Prescott and Simon Stokes for their patience and enthusiasm and continued support and scrutiny. Lilla Rebellato thank you, as always, for your love and support. Finally, I want to thank all the wonderful Royal Holloway students on the Three Sisters Production Project 2005 – Antonia Christophers, Jose Maria de Tavira, Dan Fisher, Natalie Gardner, Greg Harris, Karen Jones, Robert-Jan Lewis, Sophia Lingis, Sophie Lowthian, Sue Mapp, Martin Matthew, Micky McMahon, Sorrell Moore, Virginie Morice, Ann Sandham, James Simpson, Emily Stride, Yui Terada, Jane Thomas, Collis Tooth, Hannah Trevelyan, Alastair Whatley, and Charlotte Wylie – for whom this play was first conceived and to whom it is dedicated.